Drawings

Drawings

"My Woman"

ENRICO BEDINI SCULPTOR

Copyright © 2014 by Enrico Bedini Sculptor.

ISBN: Softcover 978-1-4990-8605-8
 eBook 978-1-4990-8606-5

All rights reserved. No part of this book may be reproduced or transmitted in any form or by any means, electronic or mechanical, including photocopying, recording, or by any information storage and retrieval system, without permission in writing from the copyright owner.

Any people depicted in stock imagery provided by Thinkstock are models, and such images are being used for illustrative purposes only.
Certain stock imagery © Thinkstock.

This book was printed in the United States of America.

Rev. date: 05/08/2014

To order additional copies of this book, contact:
Xlibris LLC
0-800-056-3182
www.xlibrispublishing.co.uk
Orders@xlibrispublishing.co.uk
523887

"shape"

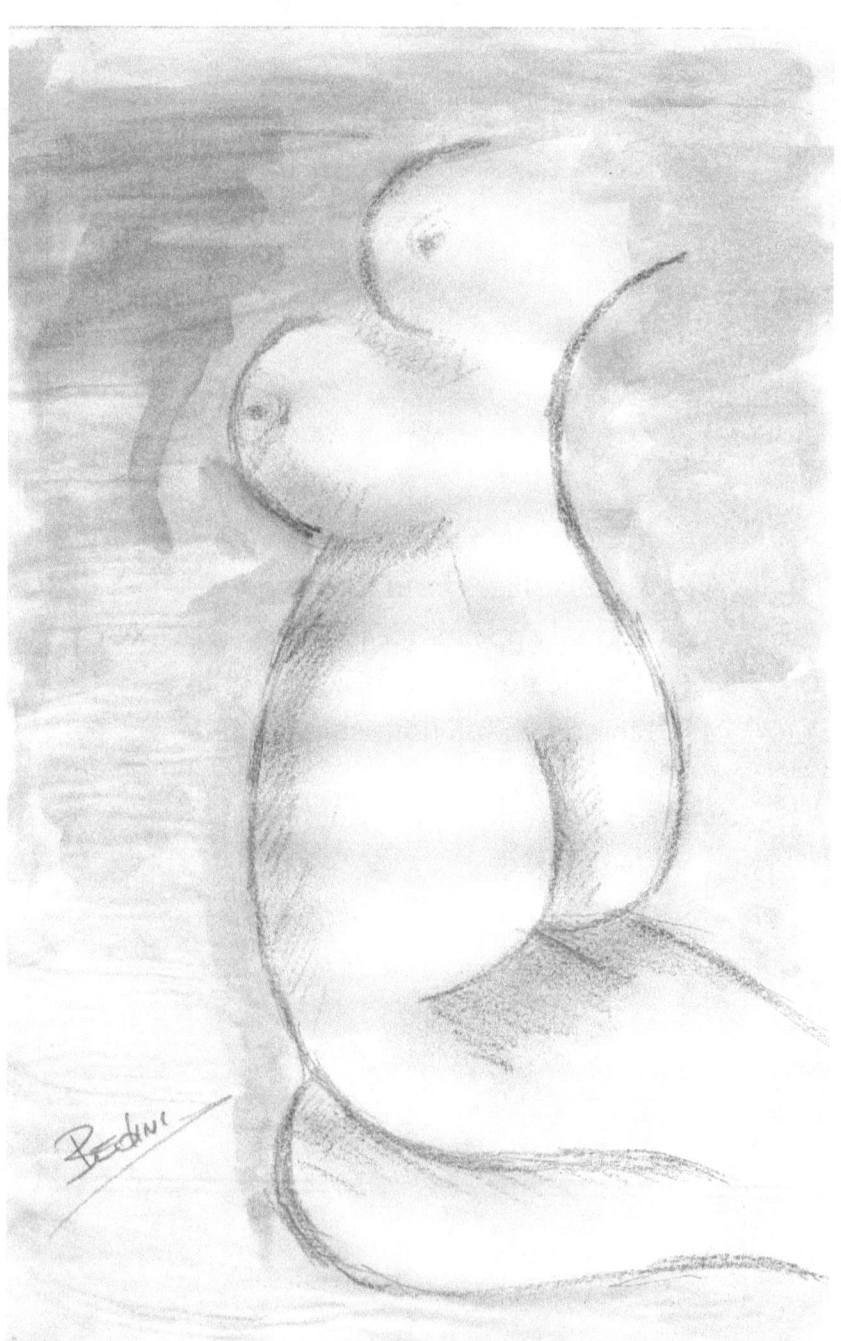

"Enrico catch the woman in the various stages from the first virginal appearance look.
Like the flower has his cycle, from Blossom to full flourishing."

"I am the woman"

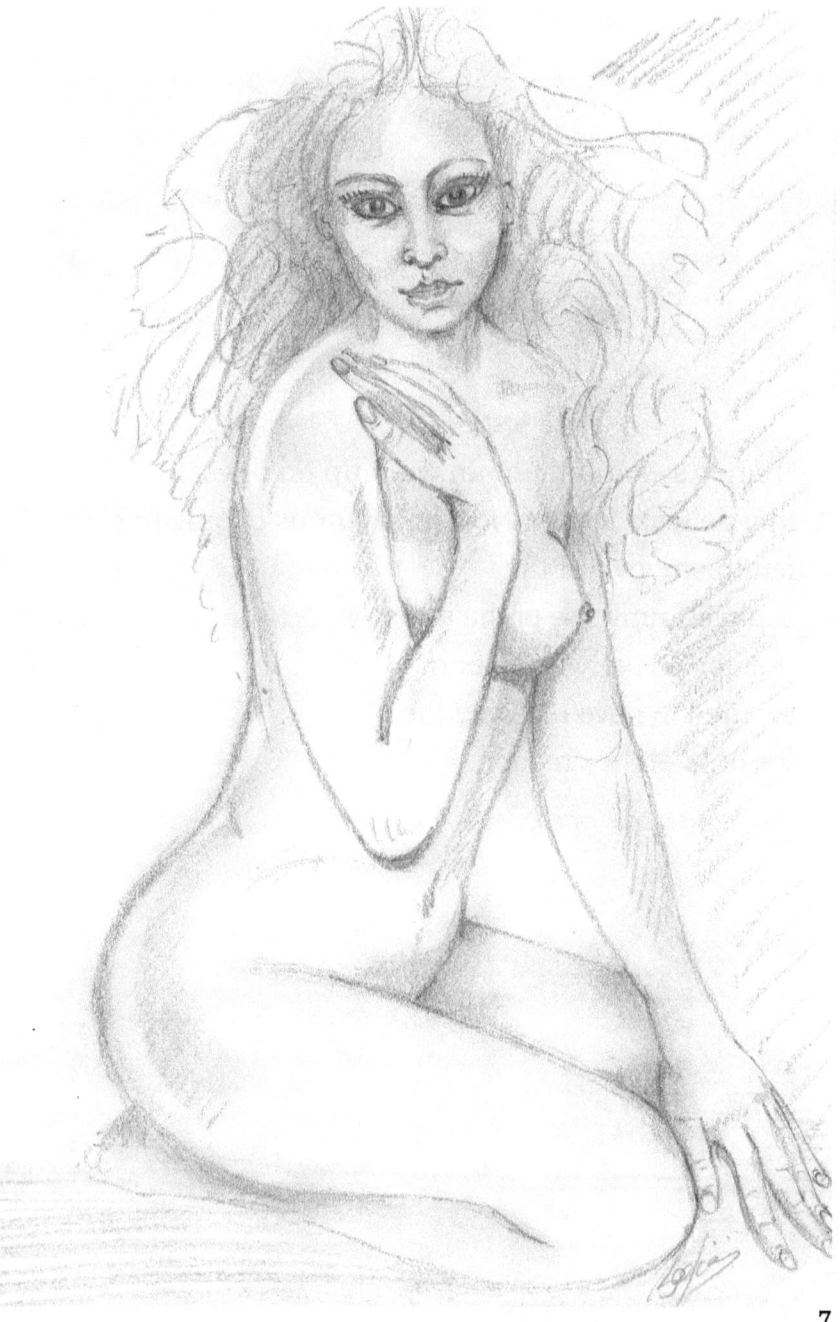

"Enrico's woman remain wrap up on oneself
in a delicate tension, it is an olympus of only populated
feminism toward the
sculpted universe of the artist
that for divinely revelation
seemed to have received the
formula of the creation.

"*a woman is an attractive flower*"

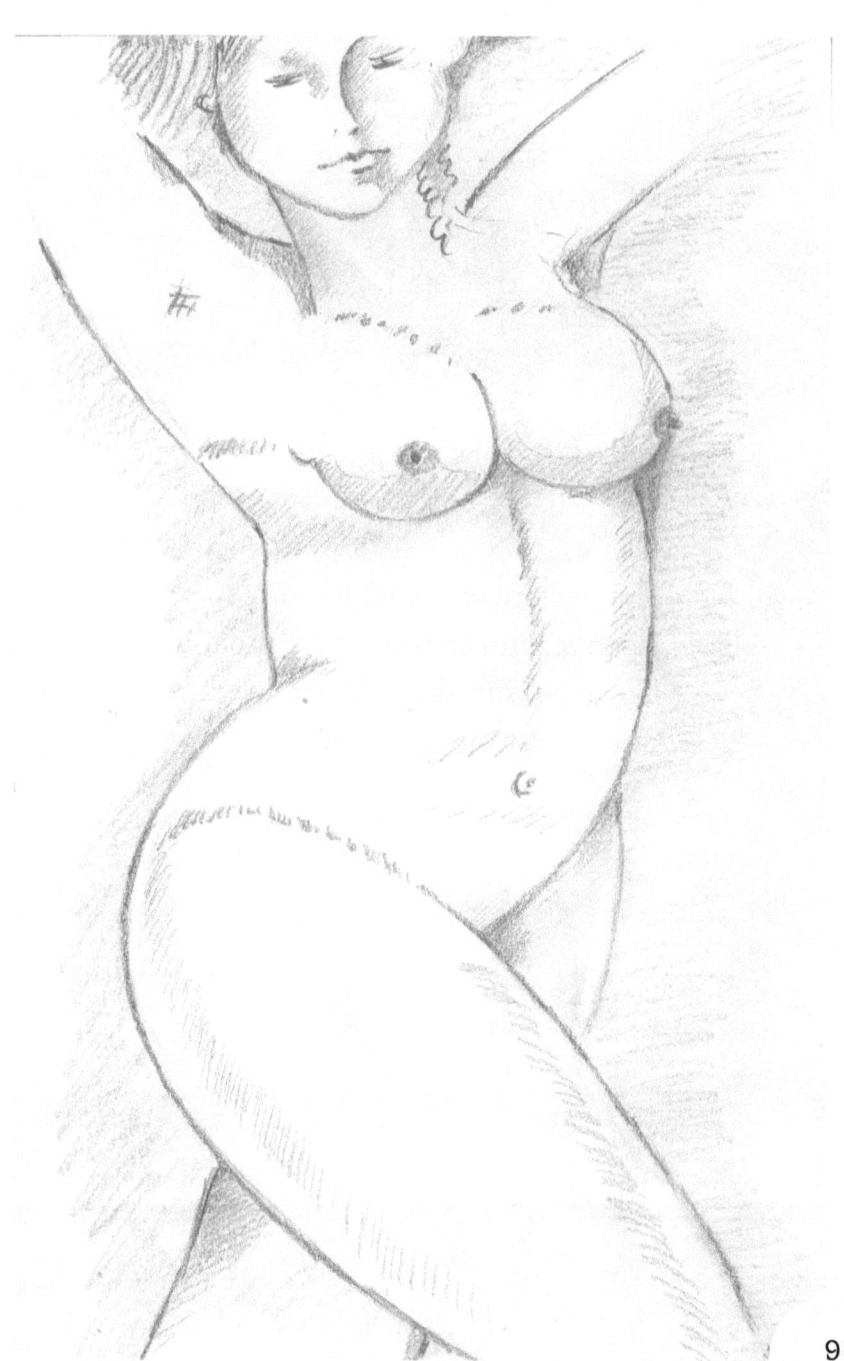

The posture collected let you
catch a glimpse of intimate motion
like green meadows, lilac flowers
the sun in your heart.

"woman is the miracle of creation"

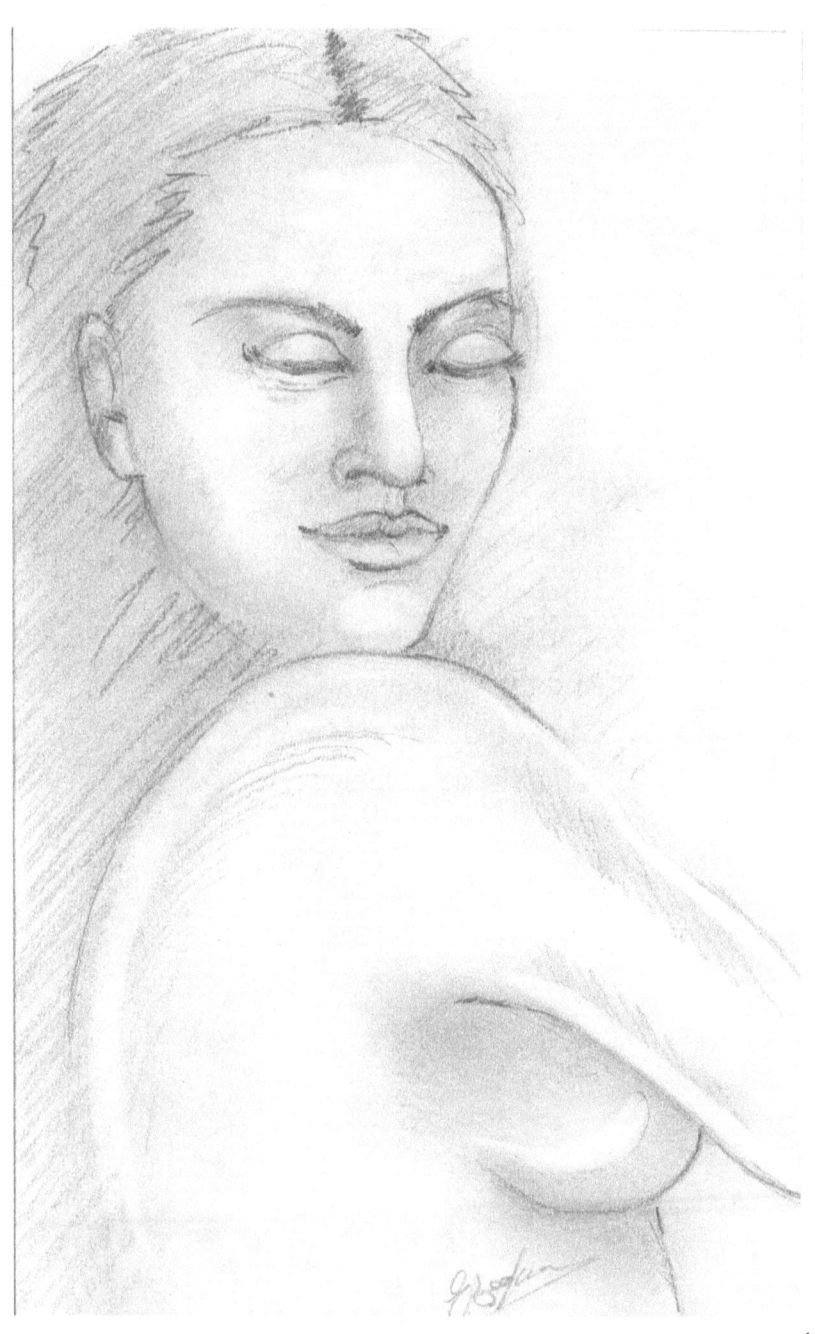

"The woman without shade"
The fields plowed of Afrodite.
"The sculptor evoke form"
And the woman
(Mother-Goddess-Muse)
Is his shape archetype.

"*woman is the central figure of the universe*"

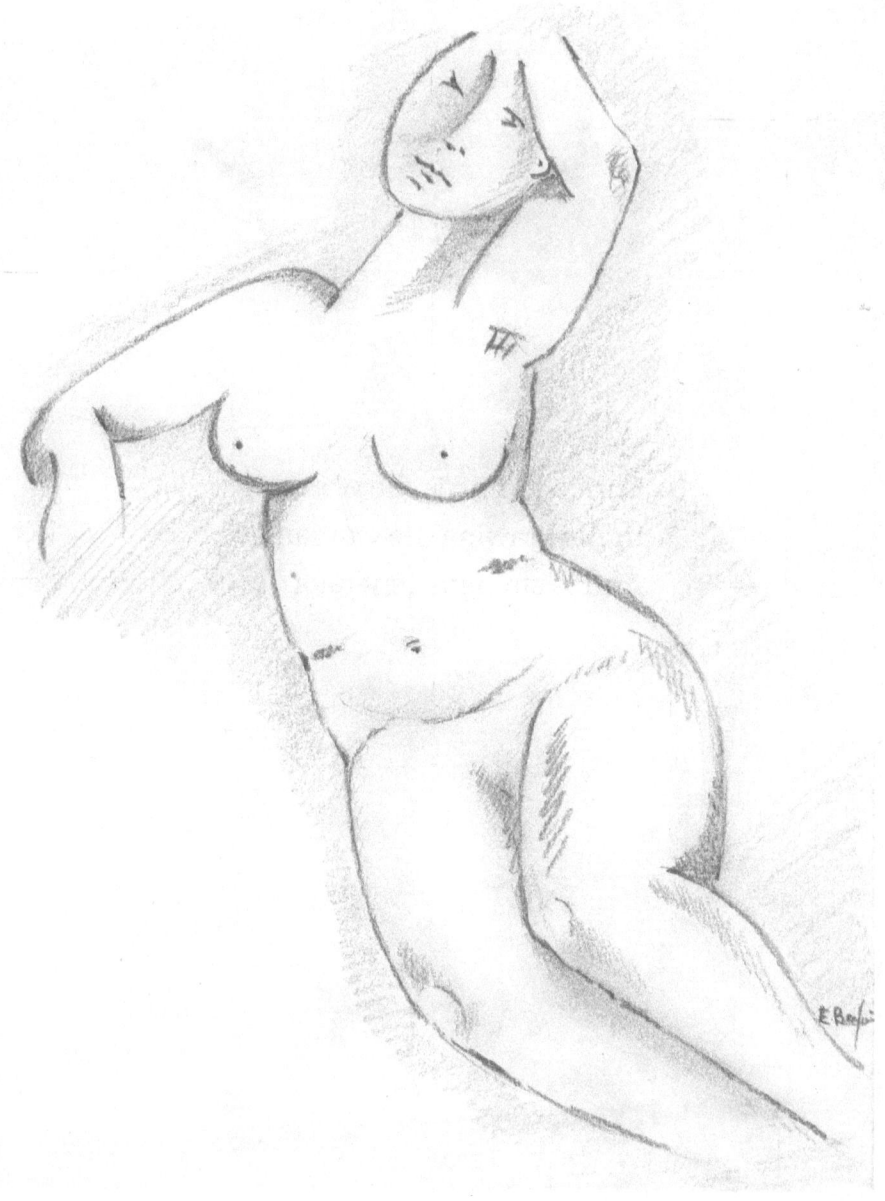

Enrico theme is the woman
In his drawing the woman live
And is strength generator.

"woman is a beautiful gift"

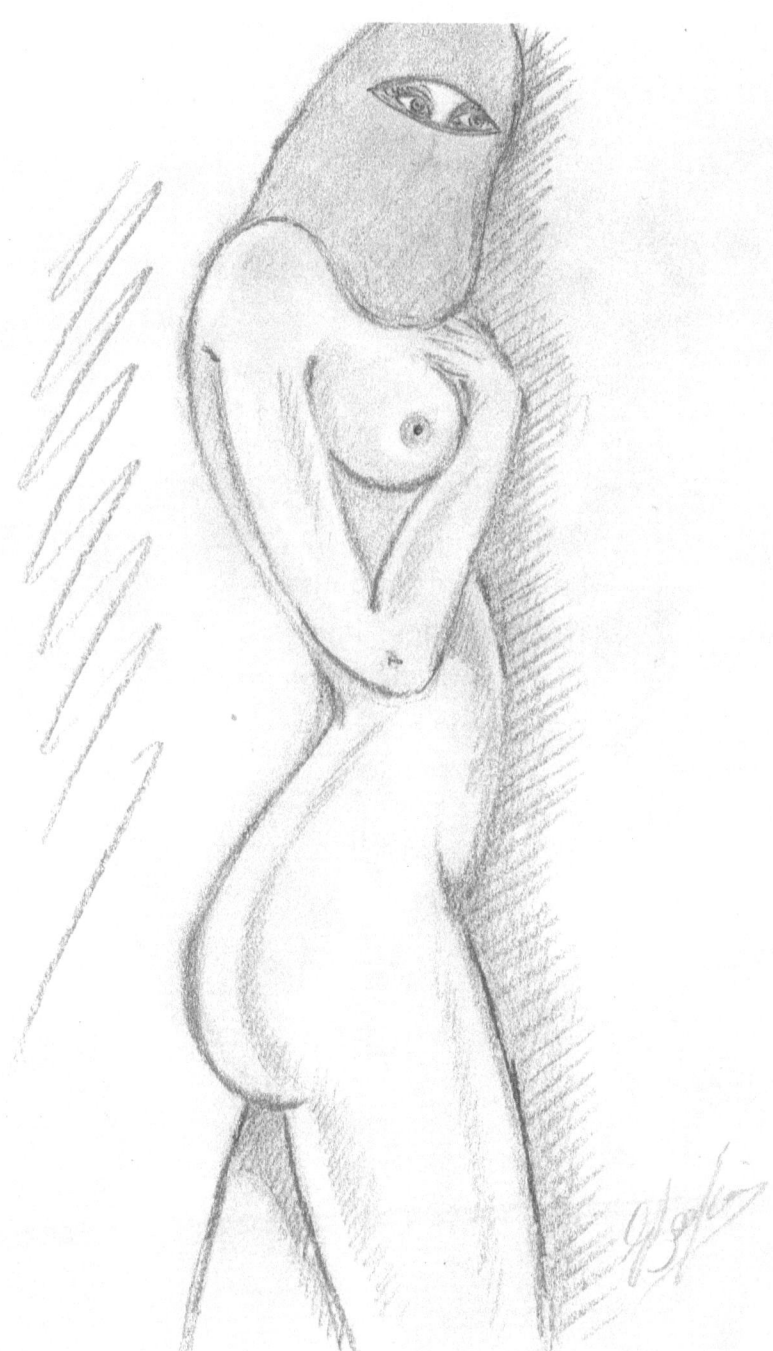

Enrico study and investigate
The voluptuous linears.
Of the fantastic shape that is
The female body.

"a man needs a woman"

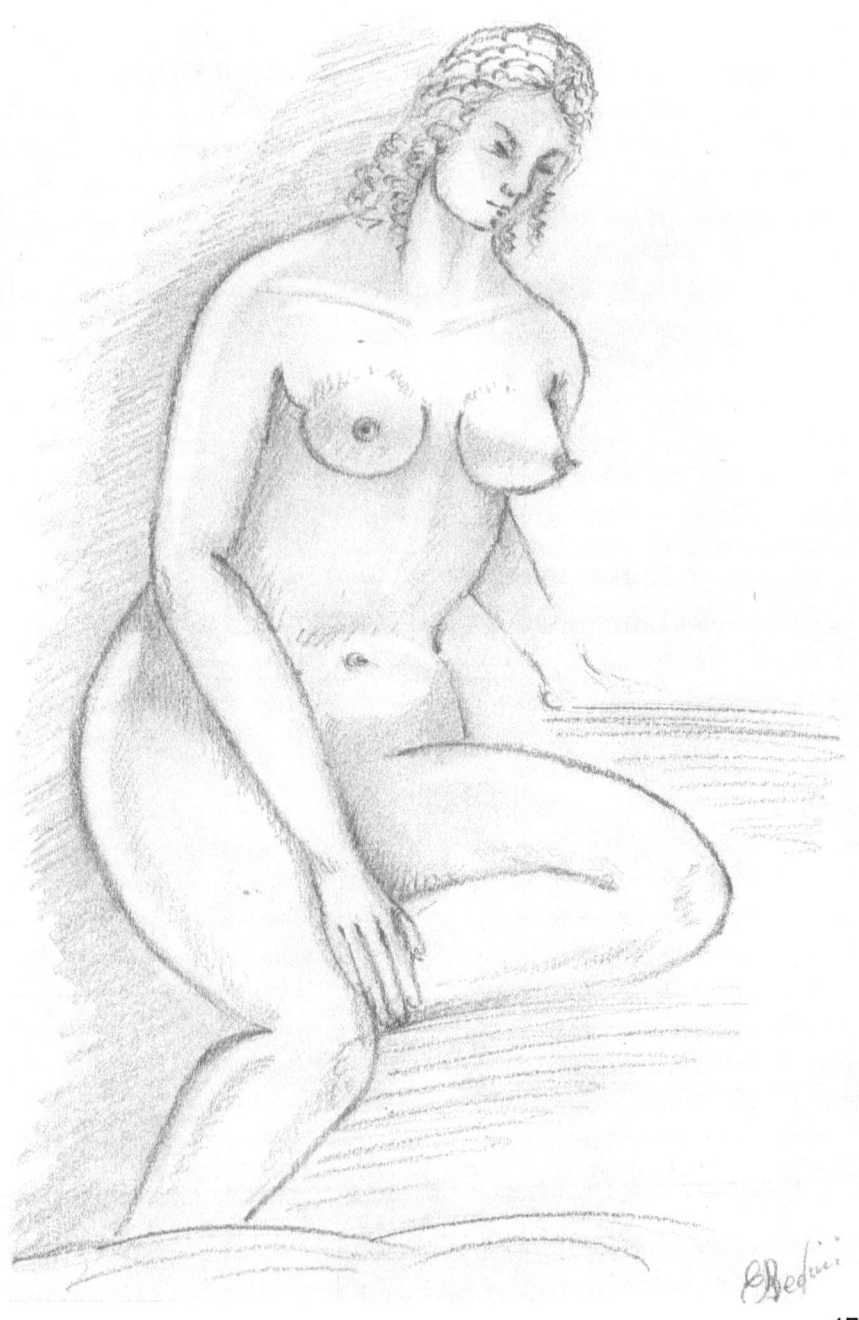

Enrico the artist make to
Emerge from the obscure nothing
A creature came in to the light of
day .

"I greet woman for beauty in body and soul"

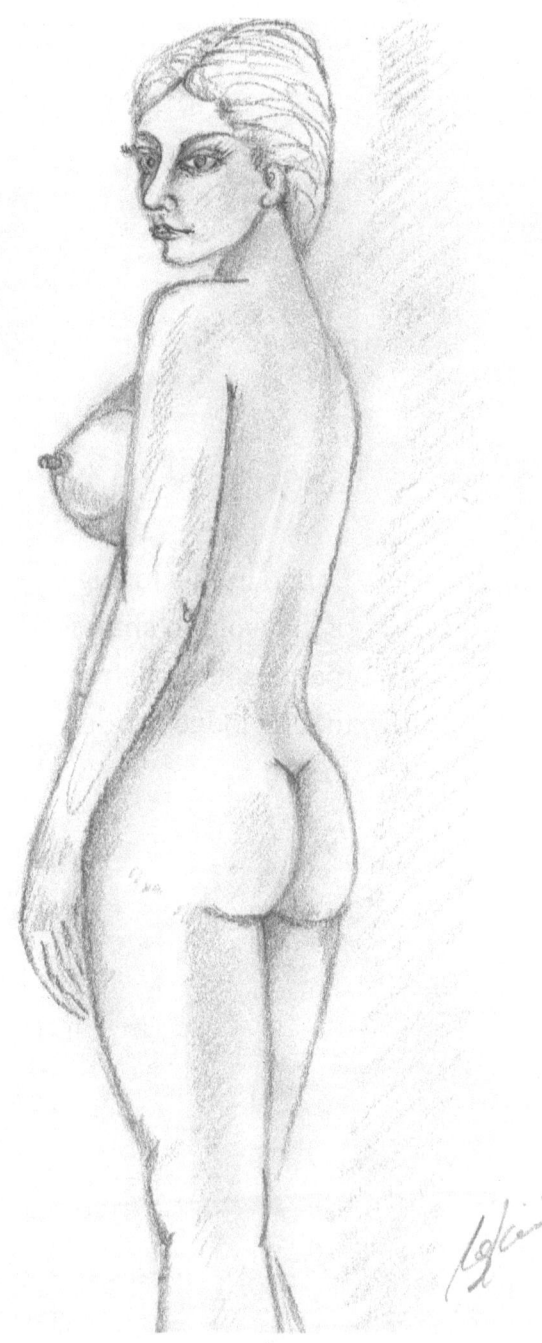

Enrico in this loving
of the woman shape
manifest the poetry
that he lodge inside.

"the universe is because of the woman"

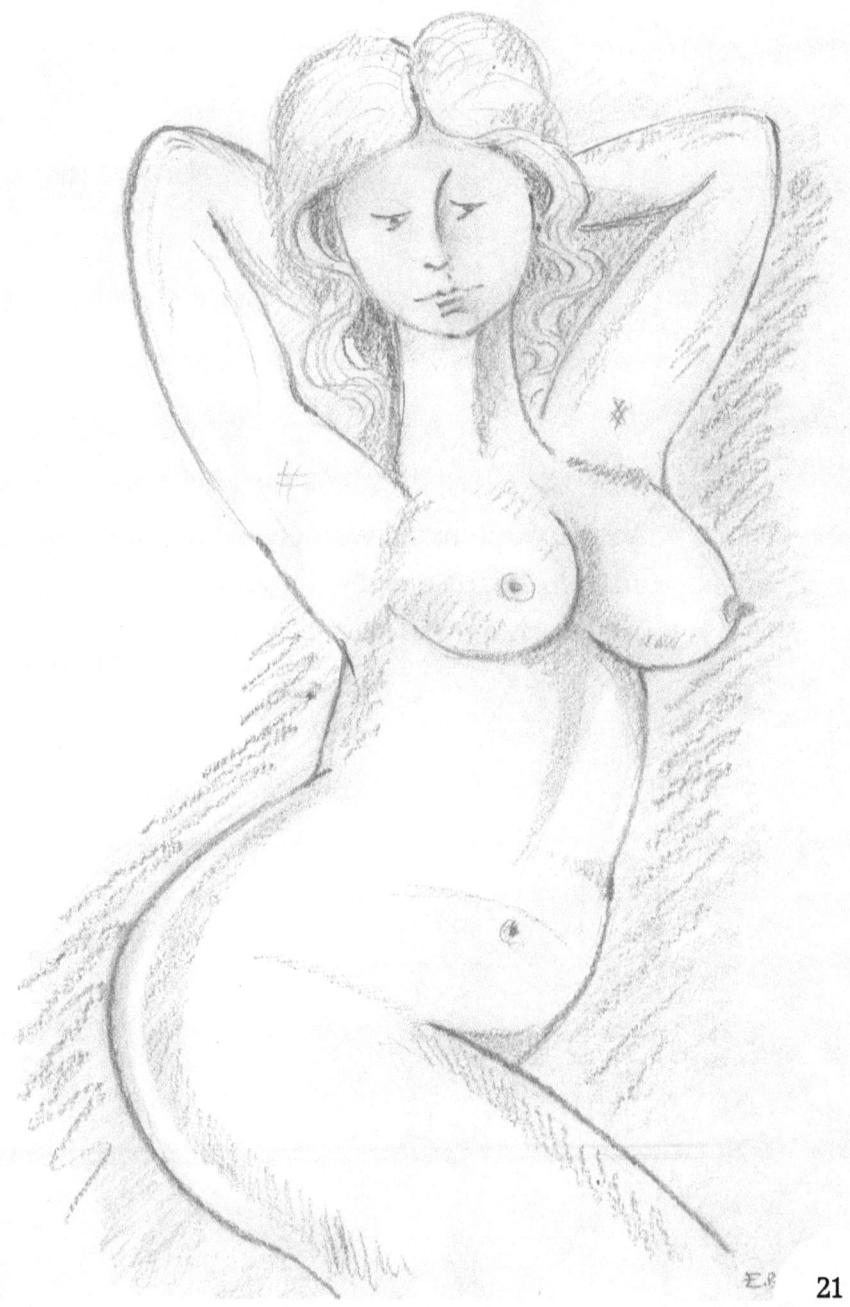

Young women, old women
In their hearts despite the years
the yearning is to be beautiful.

"woman as beautiful as can be"

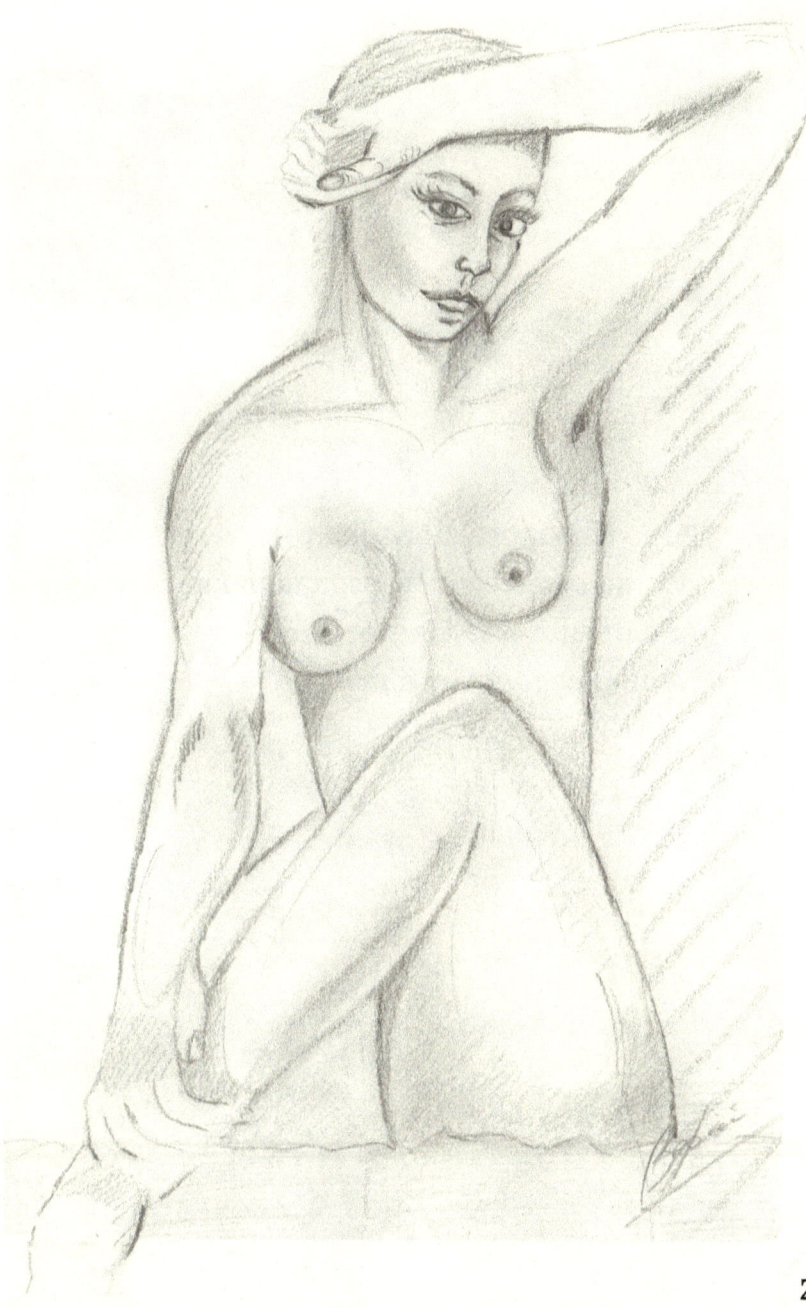

Enrico the artist knows that
"Women are power of inspiration for man
And dreams as a longing
woman be mine be mine"

"she is but only a woman"

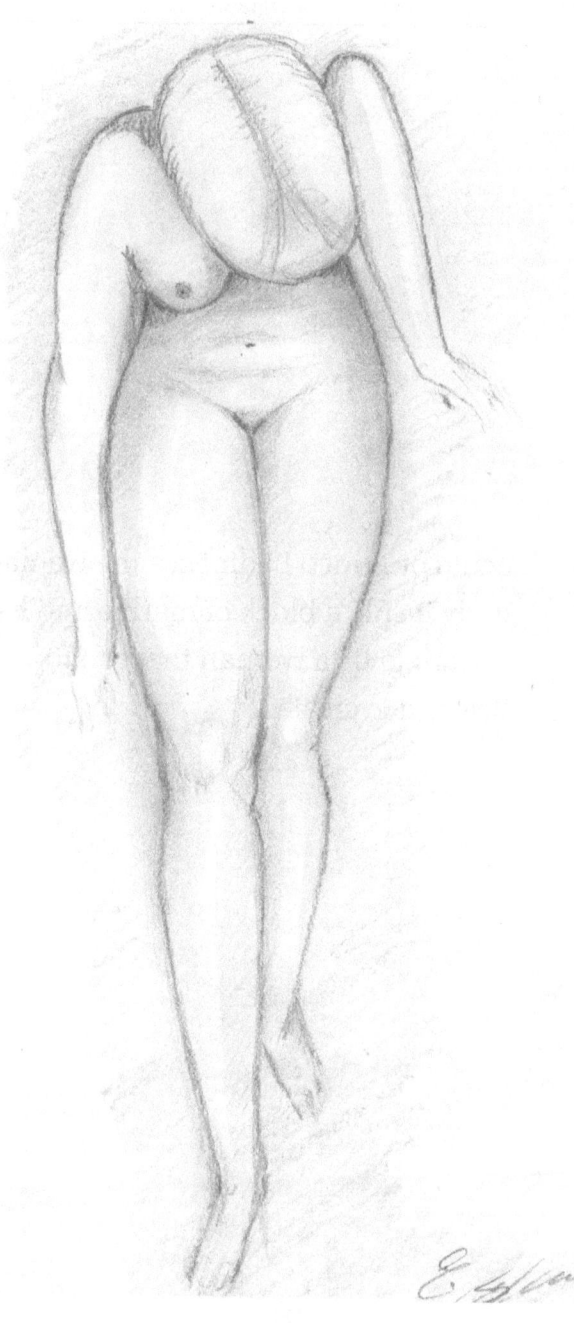

Sculptor Enrico Bedini see the woman
Body inside a block of marble and hear
"I want to be a woman that you love"
Before it is created.

"woman of my imagination's dream"

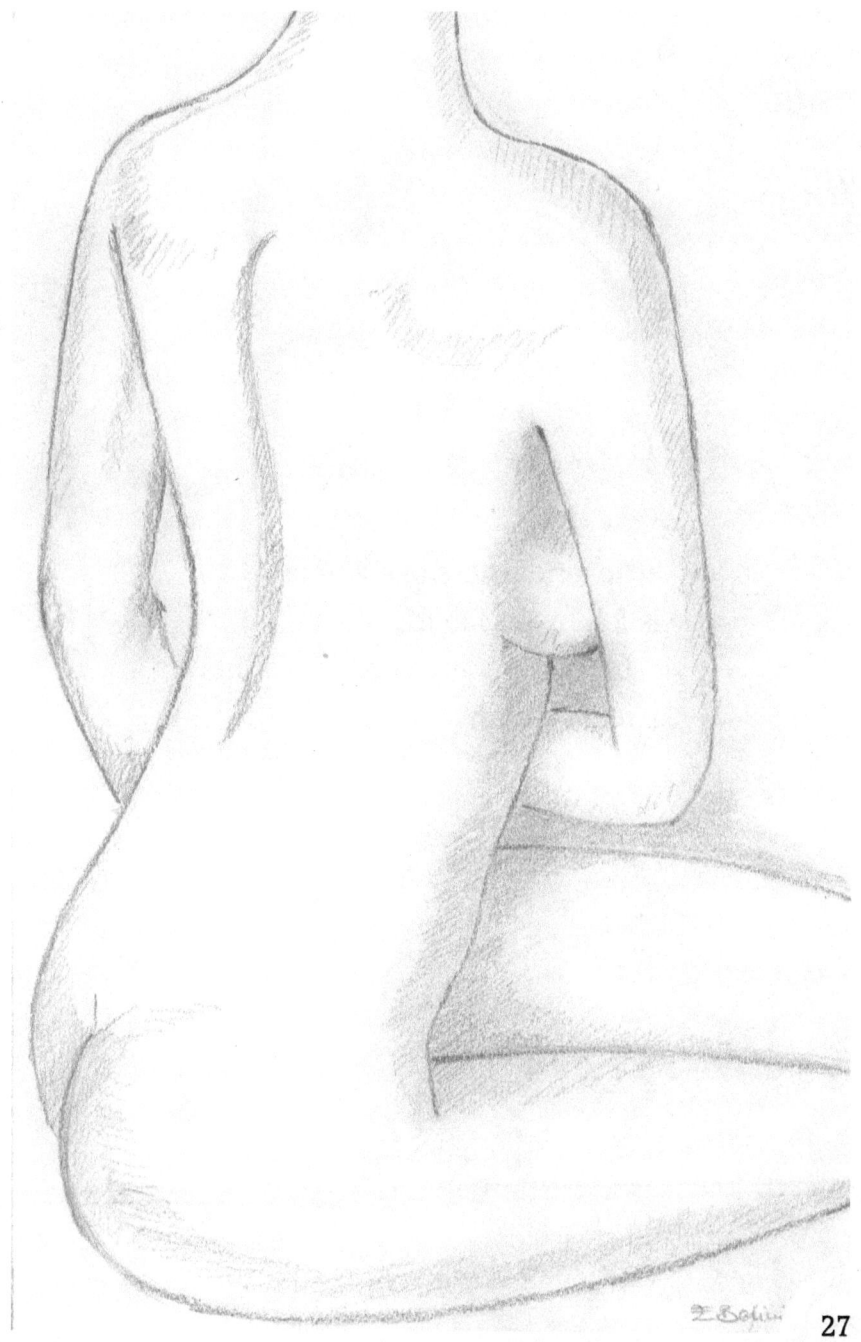

"The tenderness of a woman
Is felt by Enrico the artist
"Through my eyes I see a woman
a real woman"

"a woman of passion"

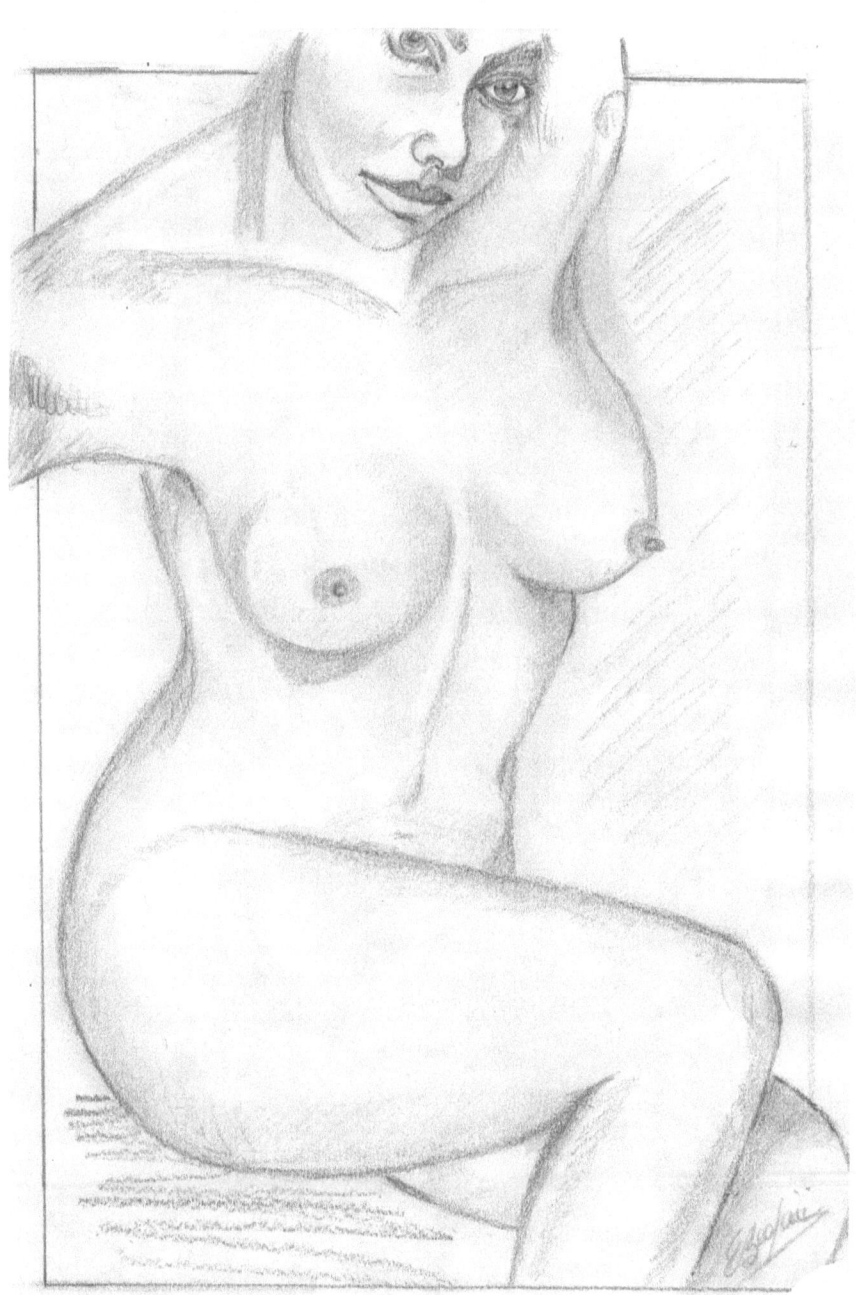

"Oh! Beautiful woman your sensuous splendour is like the shining sun your wondrous ways come from your soul"

"wonderful woman"

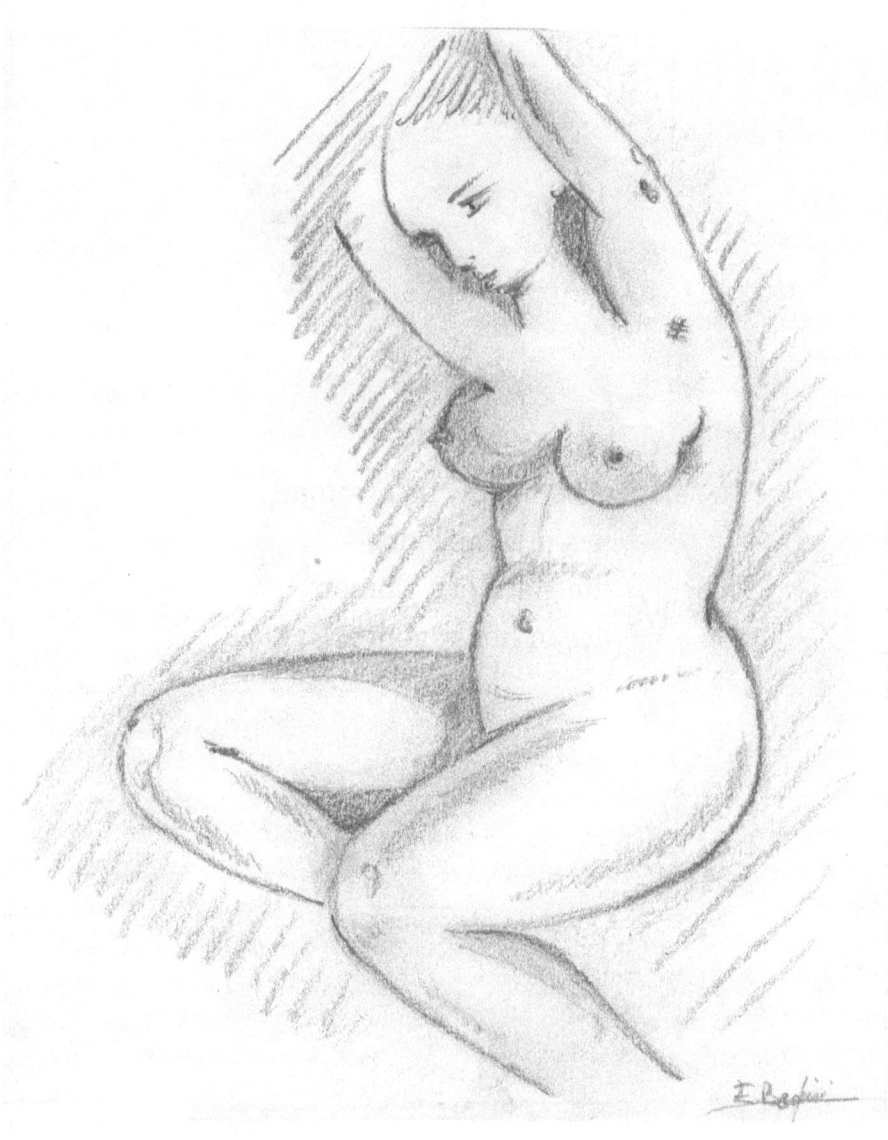

"The beauty of a woman
lies in her silence
the grace of a woman
lies in her patience"

"more of a woman"

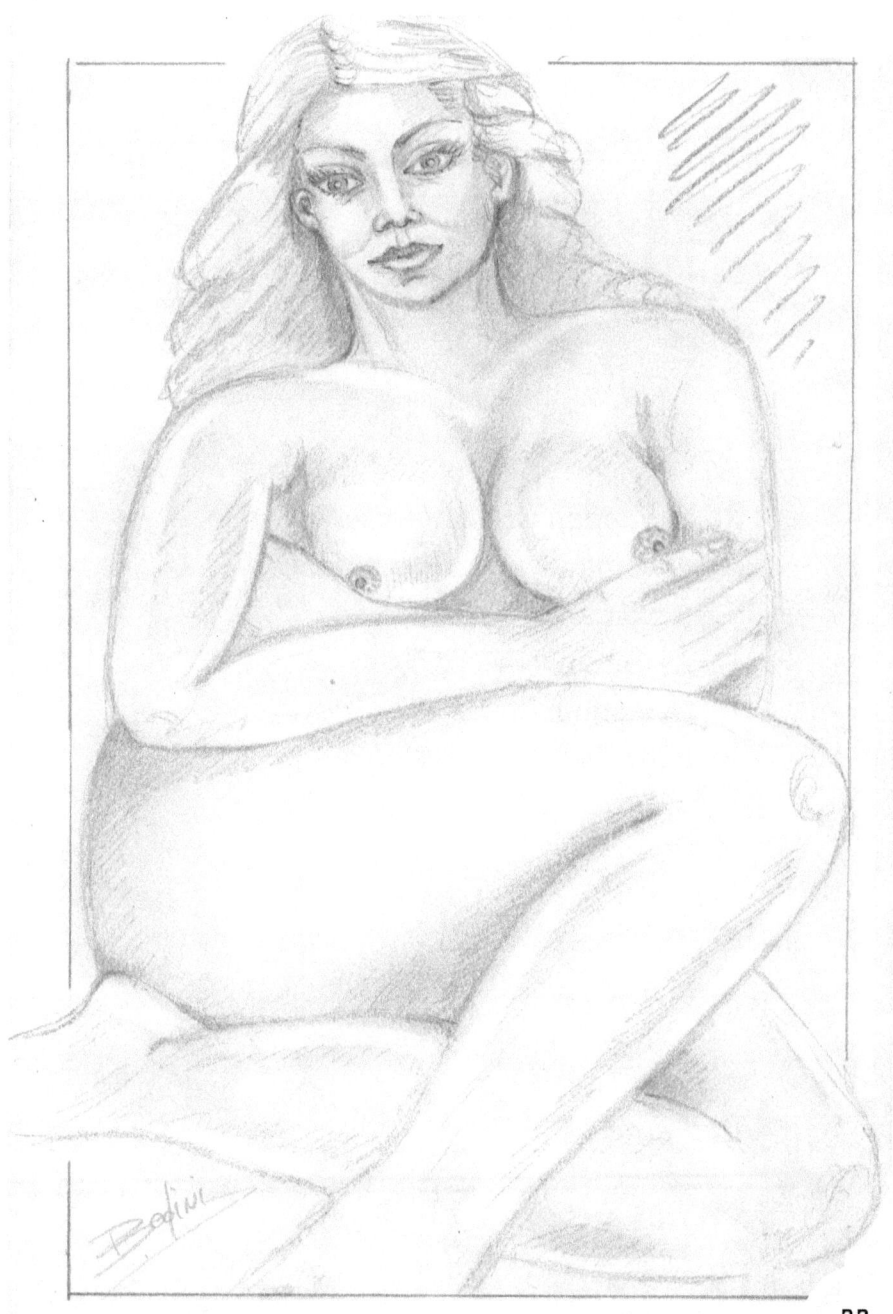

"A woman who knows tenderness
A woman who knows kindness
A woman to seek
A woman to keep."
"A woman divine
in my heart's shines"

"stately woman"

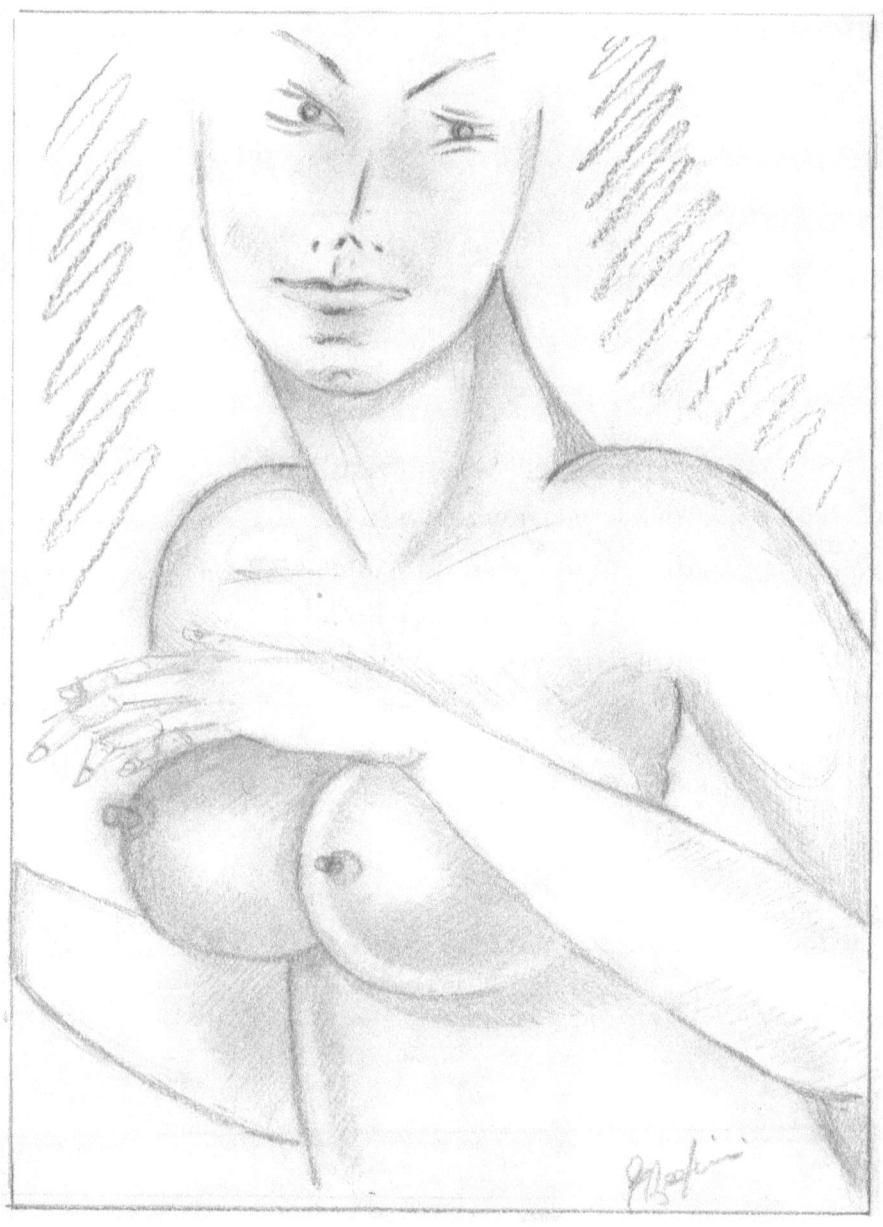

"I remember when I would dream
of a woman who could fill
dream of a woman with such grace
dream of a woman with a face
only Enrico's could create"

"*woman is tender and soft*"

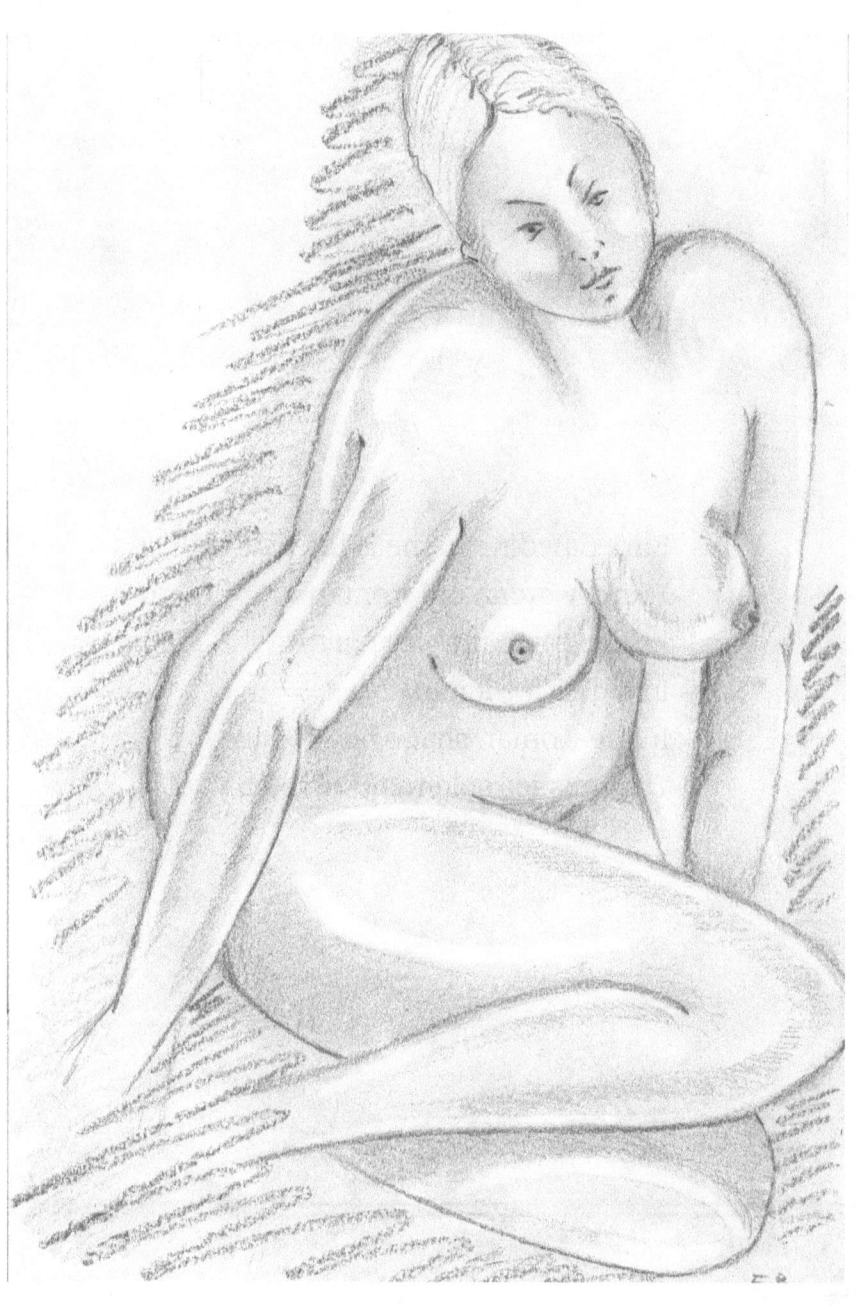

Enrico Bedini theme is the woman
Young woman old woman
Enrico catch the woman
In a delicate feminism.
In the woman shape he manifest
The sensuos splendour of the body.

"*a woman of confidence*"

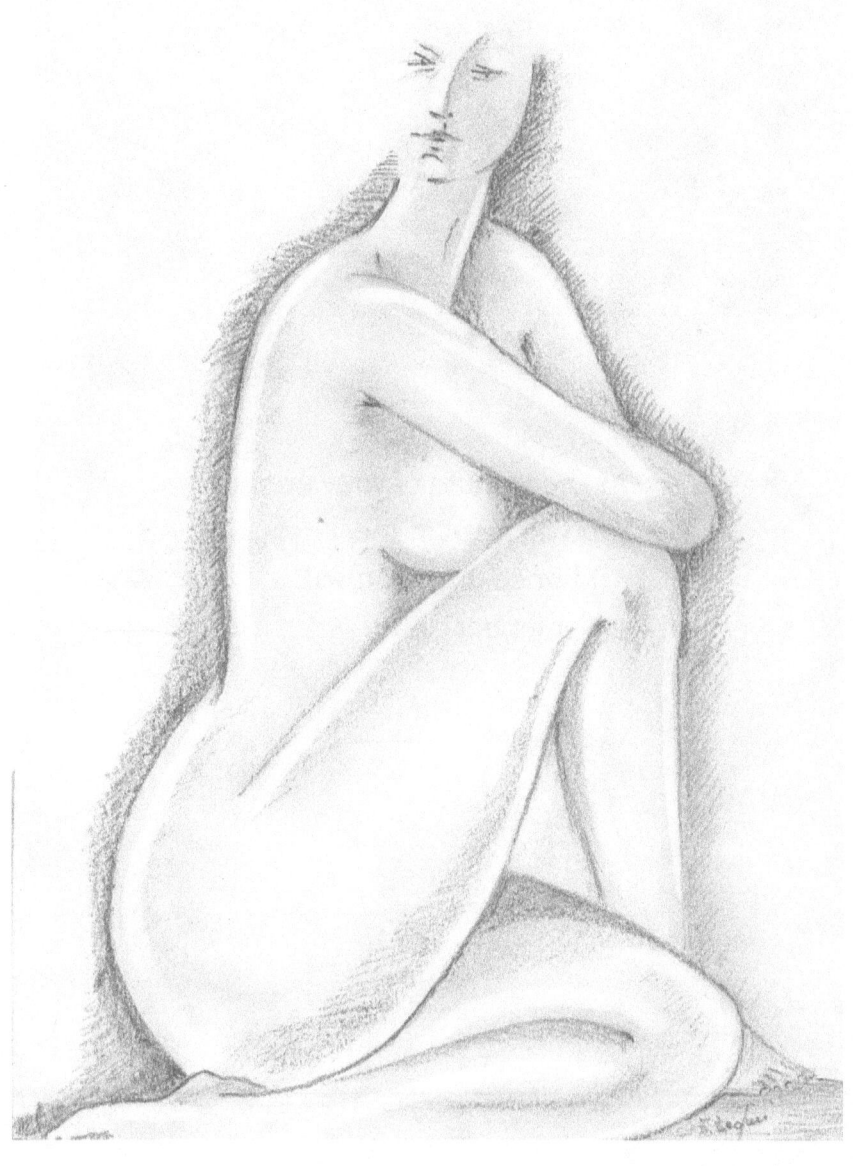

As the woman of your dream
You will want to meet her
And once done you will
never let her go.

"our existence is, because of the woman"

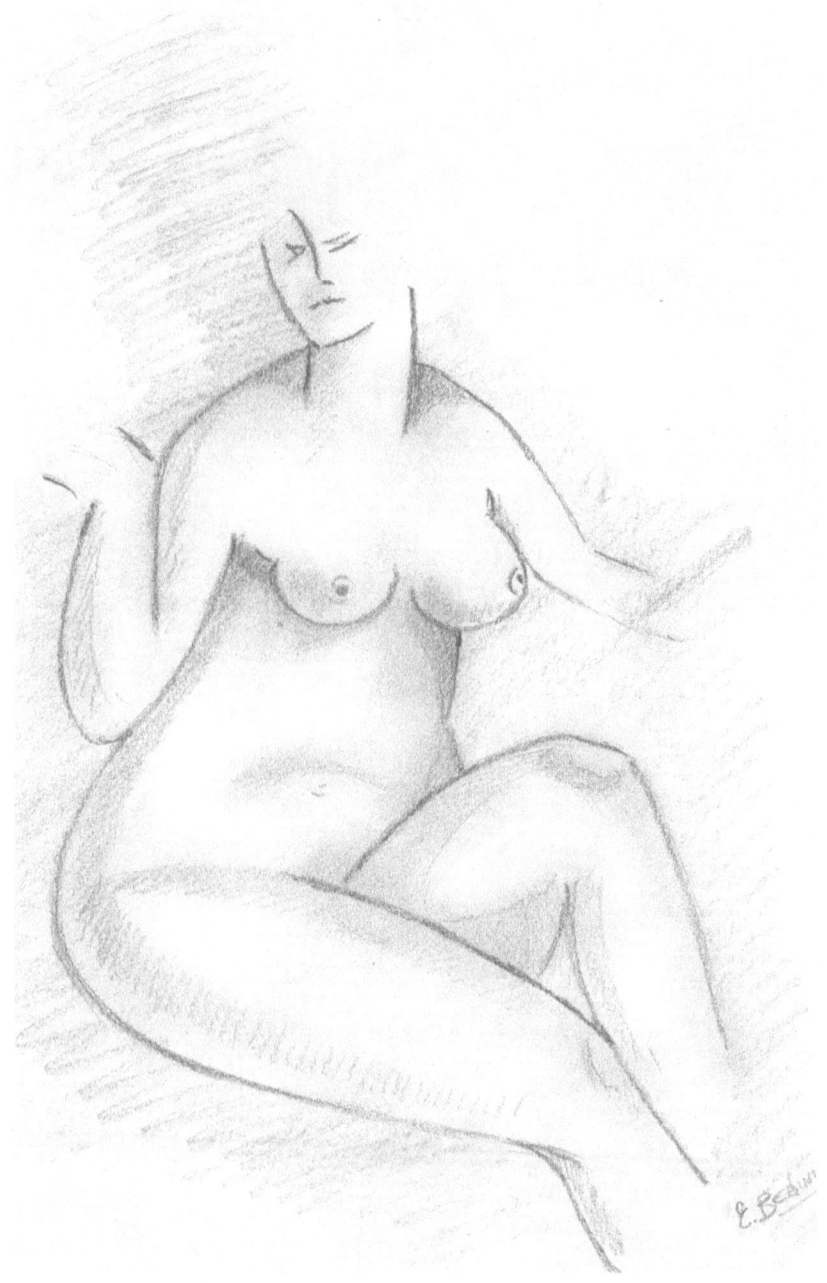

I look at the fragrant woman
And see of her languid expensiveness
While I am thrilled with the passion.

"*I love this woman*"

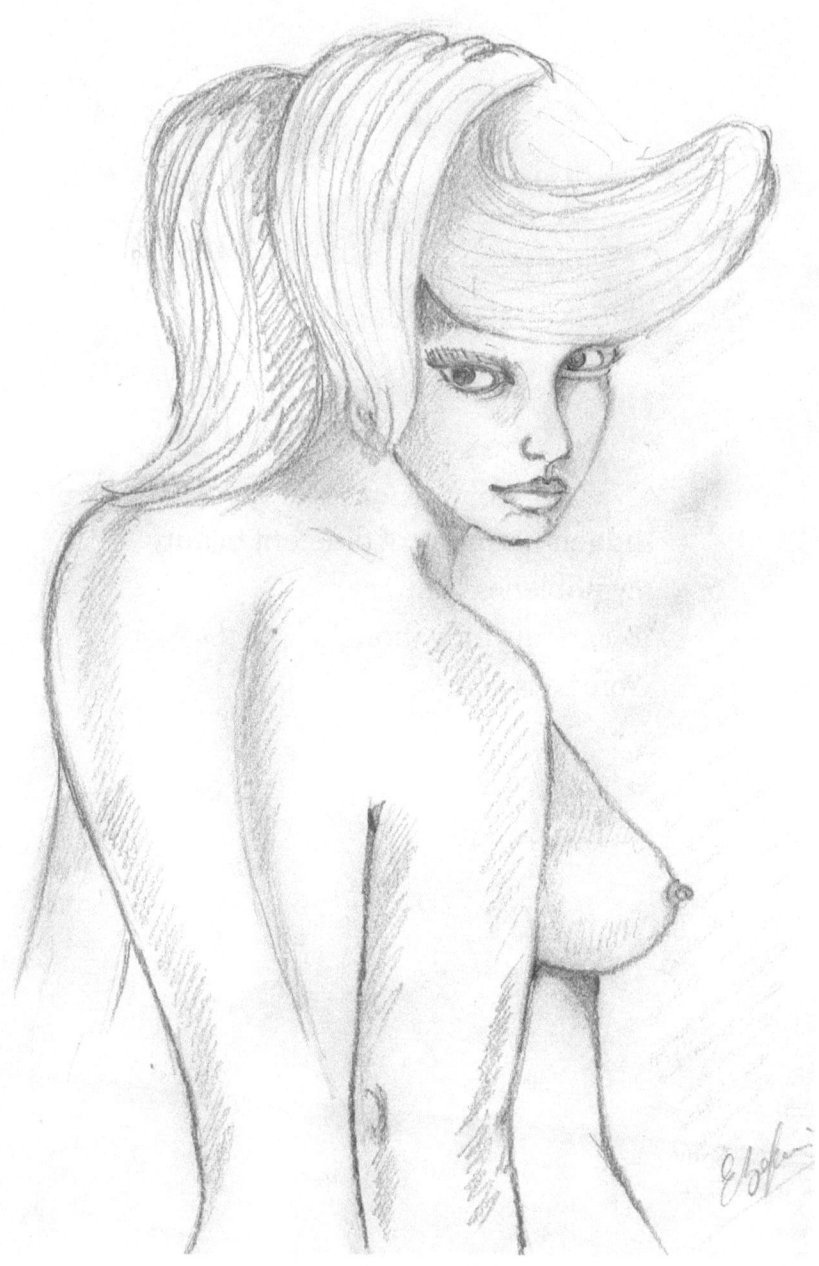

Hidden harmony of different beauty
My nobleness flower
You are my only thought
Woman is you!

"I like hot women on a cold day"

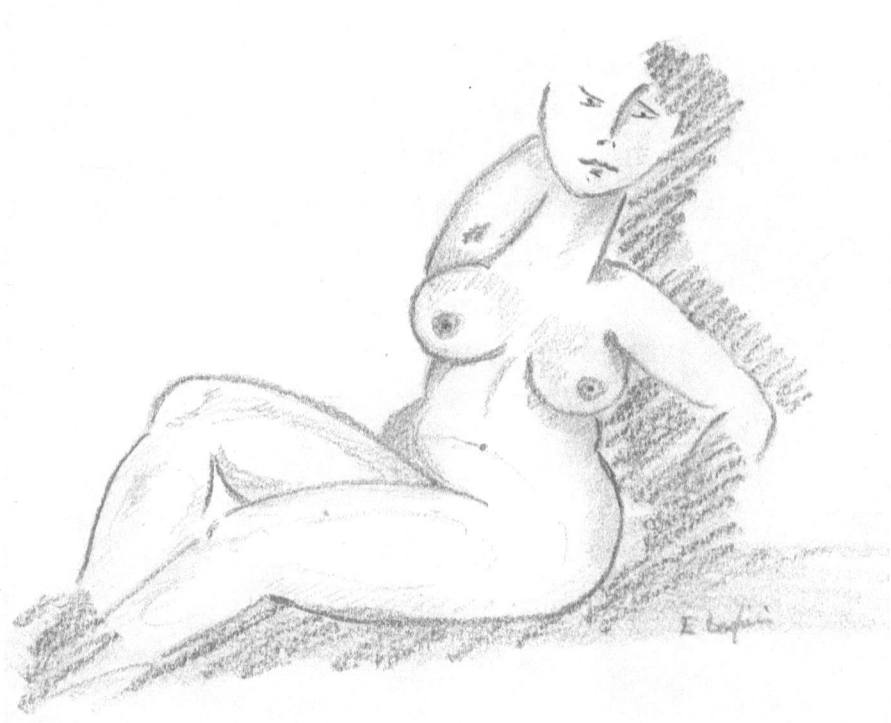

With you tomorrow and always
With you dreaming and trembling
With you from day to day
With you my burning woman.

"*I am a woman who understand*"

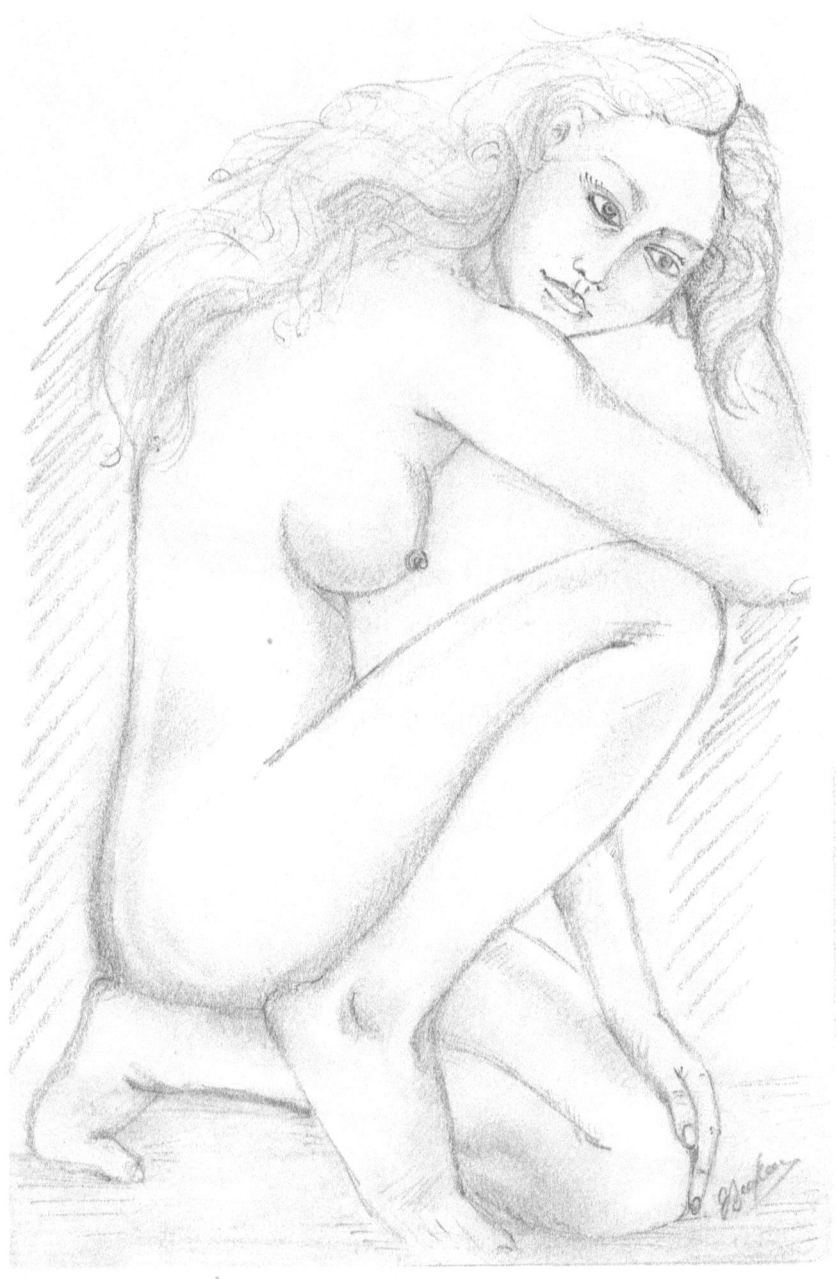

The woman body more delicate
and gentle than a flower
I would like to tell you all that
My lips will not dare.

" nothing exist without the woman "

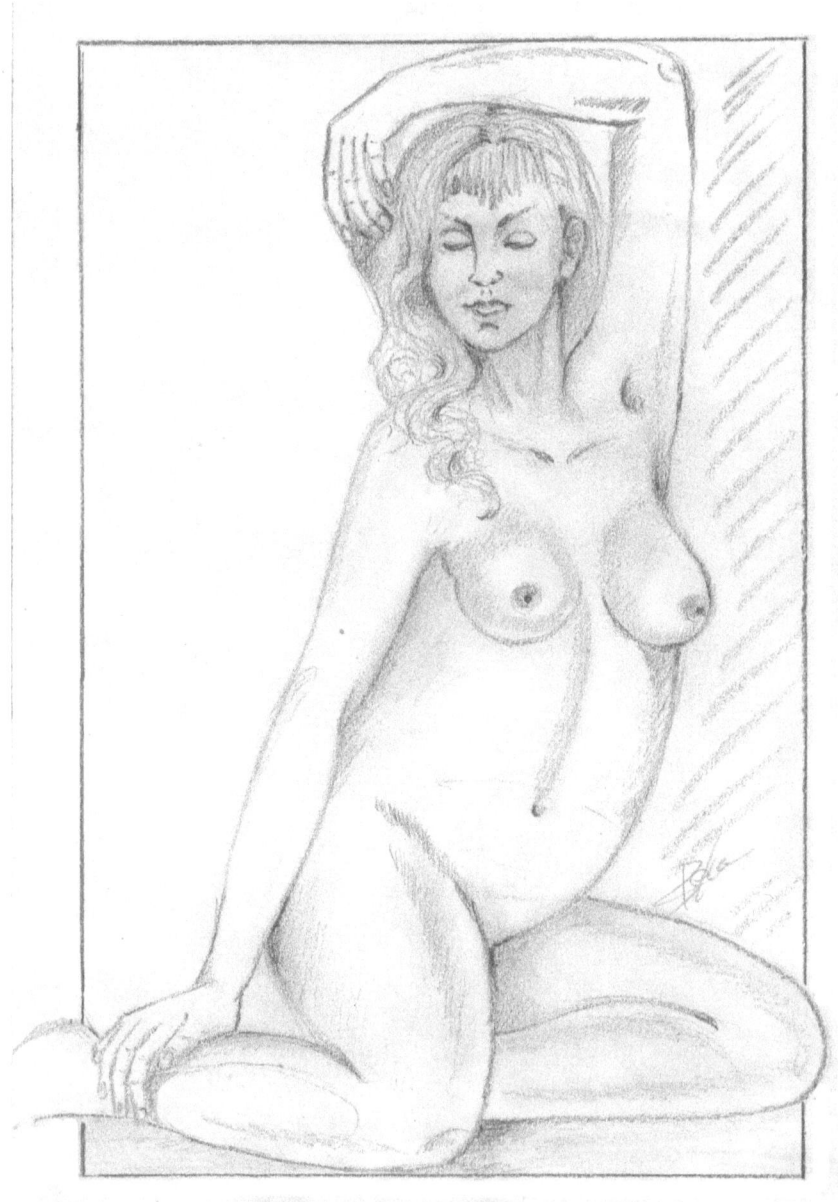

"fire in a woman"

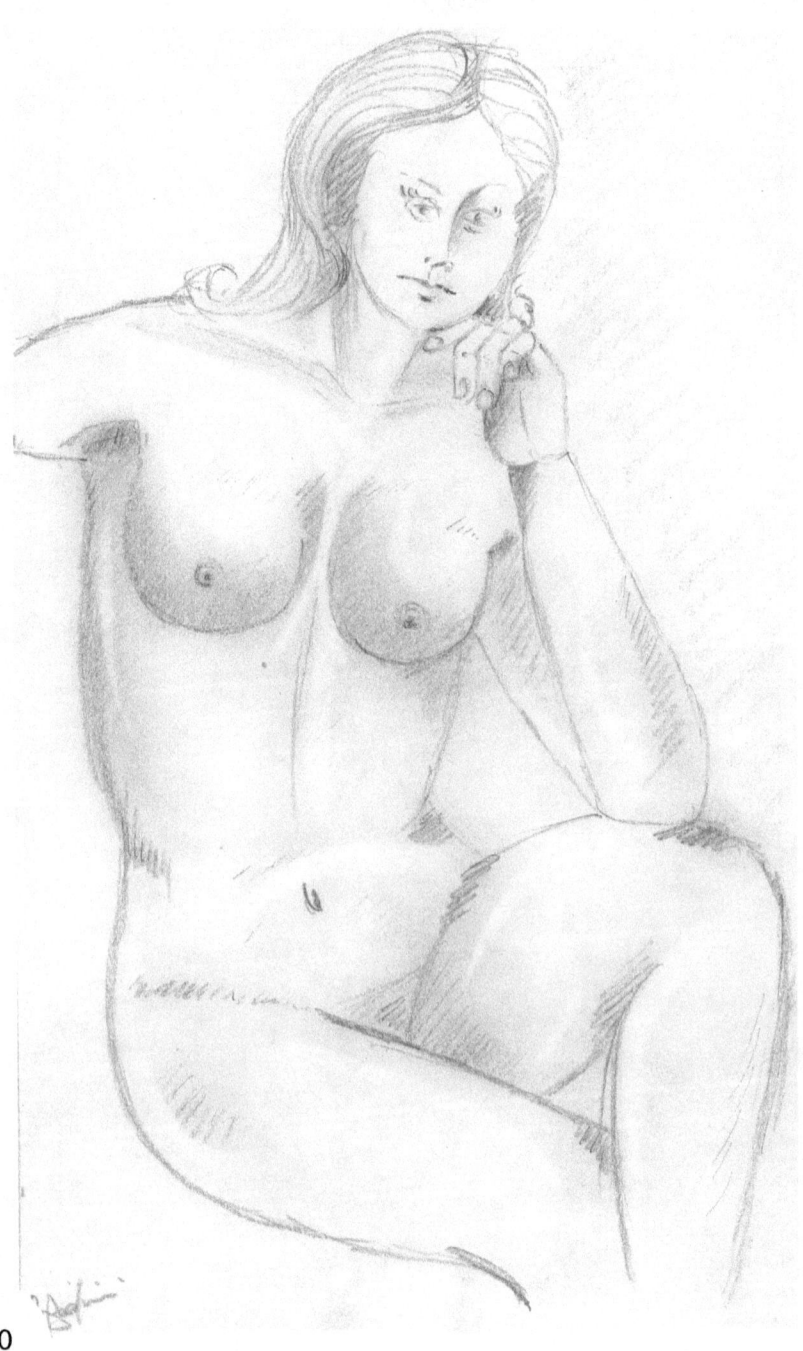

"brave woman"

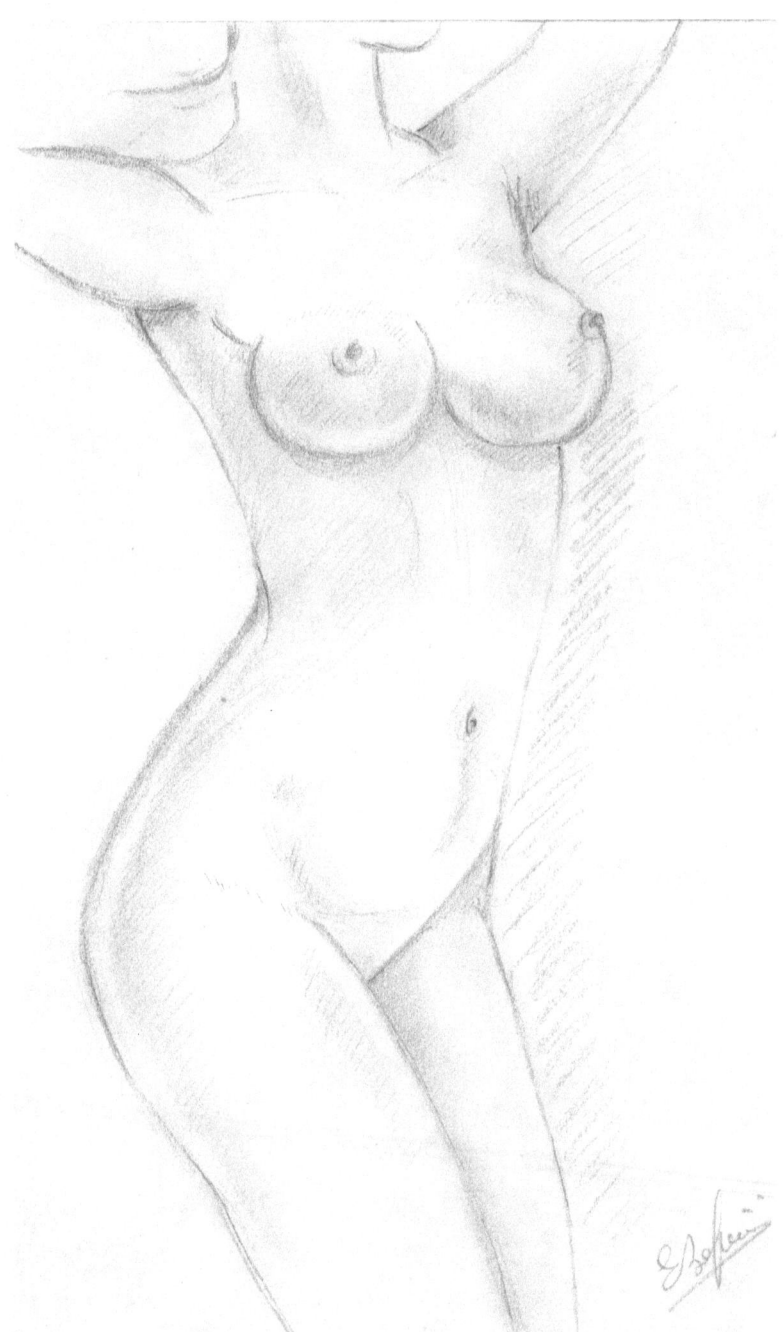

"a grown woman"

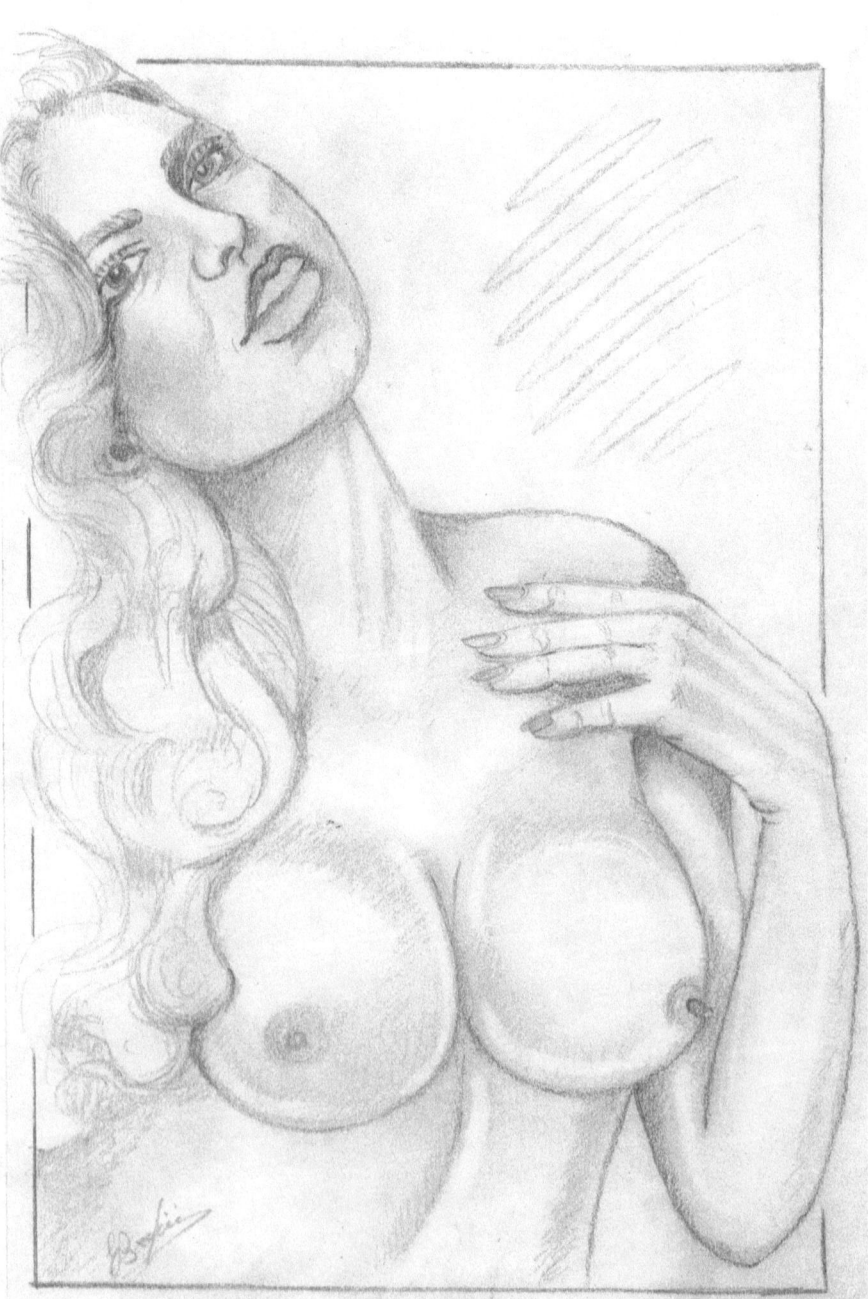

www.ingramcontent.com/pod-product-compliance
Lightning Source LLC
Chambersburg PA
CBHW021044180526
45163CB00005B/2283